An Introduction to Chinese Calligraphy

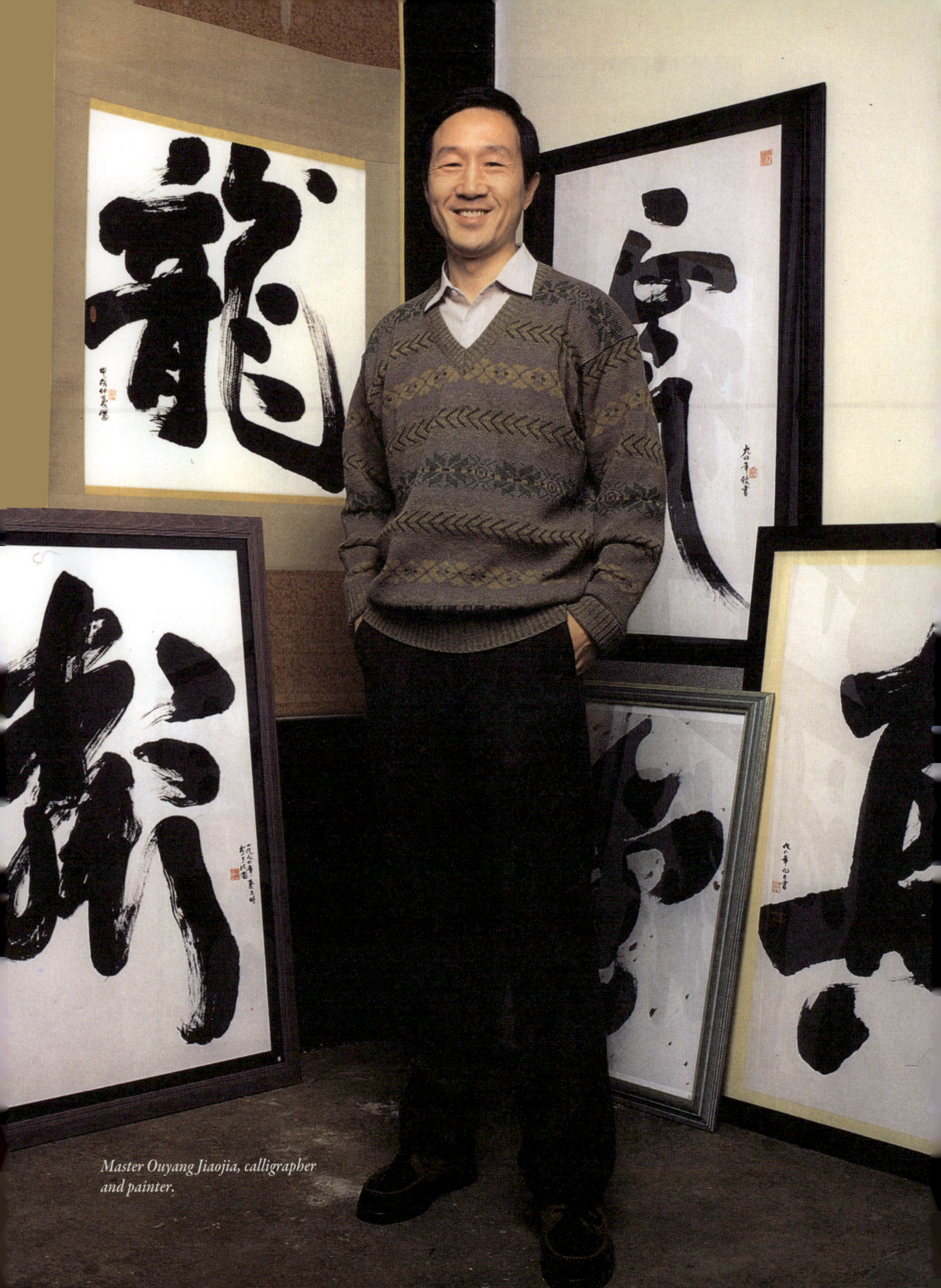
Master Ouyang Jiaojia, calligrapher and painter.

An Introduction to
Chinese Calligraphy

Lucien X. Polastron
Jiaojia Ouyang

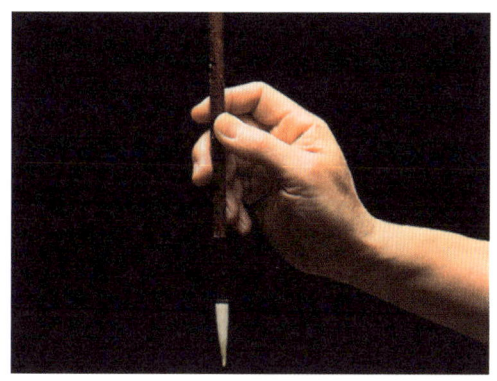

4880 Lower Valley Road • Atglen, PA 19310

Copyright © 2017 by Schiffer Publishing, Ltd.

Originally published as *Initiation Calligraphie Chinoise* by Fleurus Editions, Paris © 1995. Translated from the French by Omicron Language Solutions, LLC.

Library of Congress Control Number: 2016954652

All rights reserved. No part of this work may be reproduced or used in any form or by any means—graphic, electronic, or mechanical, including photocopying or information storage and retrieval systems—without written permission from the publisher.

The scanning, uploading, and distribution of this book or any part thereof via the Internet or any other means without the permission of the publisher is illegal and punishable by law. Please purchase only authorized editions and do not participate in or encourage the electronic piracy of copyrighted materials.

"Schiffer," "Schiffer Publishing, Ltd.," and the pen and inkwell logo are registered trademarks of Schiffer Publishing, Ltd.

Type set in Trajan Pro/Garamond Premier Pro/Syntax

ISBN: 978-0-7643-5242-3
Printed in China

Photography by Phillippe-Gérard Dupuy, unless otherwise noted

Published by Schiffer Publishing, Ltd.
4880 Lower Valley Road
Atglen, PA 19310
Phone: (610) 593-1777; Fax: (610) 593-2002
E-mail: Info@schifferbooks.com
Web: www.schifferbooks.com

For our complete selection of fine books on this and related subjects, please visit our website at www.schifferbooks.com. You may also write for a free catalog.

Schiffer Publishing's titles are available at special discounts for bulk purchases for sales promotions or premiums. Special editions, including personalized covers, corporate imprints, and excerpts, can be created in large quantities for special needs. For more information, contact the publisher.

We are always looking for people to write books on new and related subjects. If you have an idea for a book, please contact us at proposals@schifferbooks.com.

Other Schiffer Books on Related Subjects:
An Introduction to Arabic Calligraphy, Ghani Alani, ISBN 978-0-7643-5173-0
An Introduction to Japanese Calligraphy, Yuuko Suzuki, ISBN 978-0-7643-5218-8
An Introduction to Calligraphy, Véronique Sabard, Vincent Geneslay, and Laurent Rébéna, ISBN 978-0-7643-5230-0

Contents

Introduction	7
The evolution of Chinese calligraphy	9
Materials	17
How to start	25
Exercises	31
First wave: Strokes #1 to #9	*32*
First wave exercises	*40*
Second wave: Strokes #10 to #19	*48*
Summary table of the 19 basic strokes	*53*
Second wave exercises	*54*
Chengyu: Four-character phrases	59
Chart of the characters and styles	69
General rules about the order of the strokes	70
Some parting advice	72
About Japanese calligraphy	75
Glossary	78

The first Chinese characters are four or five thousand years old and simply sketched whatever they indicated. Time has abstracted these pictograms to form current script. So we shouldn't be surprised that script also adapts so well to artistic creations!

Above: "Horse," from left to right: divinatory inscription engraved on bone; on bronze; incised in bamboo; in seal script; and finally, calligraphed with a brush, in four styles.

A famous calligrapher once assured me that calligraphy was like a game of golf: an art whose practice is based on breathing, patience, and a sense of space.

Anyone who observes the lively and precise to-and-fro movements in the air of a hand holding a brush, is struck by the impression of serenity and gentle concentration. Seeing a skilled calligrapher in action, we have a sudden yearning to enter into this world.

Chinese calligraphy—along with its Japanese descendant—is an art that's been, until recently, fiercely closed off: a handful of Westerners know a little about it, but they don't seem to have a burning desire to share their secret garden. Good masters are rare and can only accept six students at a time. As for books or guides translated from Chinese or Japanese, they were written for native Asian readers, whose total immersion in the language started in the placenta and who have had a brush in their little hands even before making their first fists.

So, since there isn't a book on the subject that explains in down-to-earth terms how to understand and approach this divine, but obviously attainable, art—which answers to timeless and objective rules—I decided to put all the things I've learned into this book. I must admit that the job became much simpler and pleasanter with the help of Master Ouyang Jiao-jia from Shanghai, a highly respected calligrapher in so-called regular script, and who is possibly a descendant of the monumental Ouyang Xun (557–641), who codified this basic style a great number of centuries ago.

The urge to stylize and embellish the expression of a message to the point that it becomes an art in itself is uni-

INTRODUCTION

Chinese calligraphy: An ancient skill

versal. In any epoch, in all corners of the world, even when or where writing wasn't yet practiced, everyone plays the game of turning something said into something beautiful. Therefore, there is a long history of calligraphy in Western languages, one that that goes from Roman capitals engraved in marble to the gestural-style creations of today. There are Tibetan or Sanskrit calligraphies, Hebraic or Arabic calligraphies, each having its own history and world perspective, its own schools and nuances, those that are controversial and individual, a complete infinity for each culture. You may choose to open any one of these doors.

But in the realm of calligraphy, the queen is Chinese, because quite simply the Chinese language is the only one to have chosen to do small drawings in place of words, already aesthetic, almost comic-strip-like, while the other forms of script have no other matter on which to model themselves except their alphabets. In addition, the greatest masters of Chinese calligraphy produced their masterpieces between the fourth and seventh centuries and very early launched a great wave of proselytism, a snowball of libertarian innovators, which even today amaze us and carry us along with incredible sovereignty.

Because this art, which we say "creates old men," teaches us, without weighing us down, a thousand beneficial things: breathing, how to recapture ourselves, how to see things clearly, how to learn to see what is already written on a blank page, to be the master of forms not yet drawn, how to manipulate the subtle and gentle materials that are the brush, the ink, and the paper—ambassadors of a natural paradise.

The basics, if we can say that, of Chinese calligraphy bears the pretty name of *kaishu*: "normal, square, regular script," the dictionary wisely tells us. It is from this clear and indisputable line, with its school-like rules but overflowing with life and illustrated by magnificent examples over the ages, that you will feel that you've been given wings; so go profitably wild and invent your own style; you'll need to.

You are now going to enter a marvelous world. There will be downstrokes, there will be upstrokes, there will be glissandos and serifs, everthing that makes painting enjoyable, and at the same time, the pleasant disorder of playing with a vocabulary that resembles a game of building blocks; you'll communicate with some visionaries—the ancestors of a quarter of humanity, and of a large portion of modern art to boot.

The evolution of Chinese calligraphy

From shamanism to lyrical abstraction

In the beginning, it was the era of shells and scapulas: before paper and brushes existed, Chinese calligraphy was practiced with a chisel on hard material, such as tortoiseshell, bones, stone, or bronze. We called the styles that followed this distant past "seal script," because today they are used in seal engraving. This style is called *zhuangshu** in Chinese and *tensho* in Japanese.

Different styles

It was from a rather stiff brush—was it camel-hair?—that the style called clerical script (*rishu* in Chinese and *reisho* in Japanese) was born, around the third century BCE. Very elegant forms arose from this, with well defined downstrokes and upstrokes.

Then came regular script (*kaishu* and *kaisho*), whose clarity allowed for both good legibility and easy reproduction.

This script also allowed a bit of the writer's personality to be expressed. Ouyang Xun (557–641) is considered the great harmonizer of regular script; Liu Gongquan and Yan Zhenqing were two other famous calligraphers of this style.

The lines of semi-cursive or running script (*xingshu, gyōsho*) are also recognizable and differentiated, but are carried out at a brisker pace than in regular script. Wang Xizhi and Zhao Mengfu, among hundreds of others, left masterful examples.

The ligature or connection between strokes, which appeared with the cursive script *caoshu* (*sōsho* in Japanese), is the path where the brush dances and where those accustomed to the style can guess the character rather than reading it. Wang Xizhu was the great founder of this loose style.

*The terms in italic can be found in the glossary on page 78.

The character FEI: calligraphy by the famous Mi Fu in cursive style. His brush slides on several details, adding lightness and movement.

Example of regular script.

Cursive script (or grass script) in all its dynamism. Only those who have first learned the regular script's stroke order can recognize the word FEI in this convulsively moving line!

This is the title of the page shown here: Fei Bu, or "chapter on the character FEI." (Fei means "fly, take flight.")

Zhu Yuming (born in 1460) is the author of this audacious written form, which unconsciously flirts with Greek letters.

Seal script.

Clerical style.

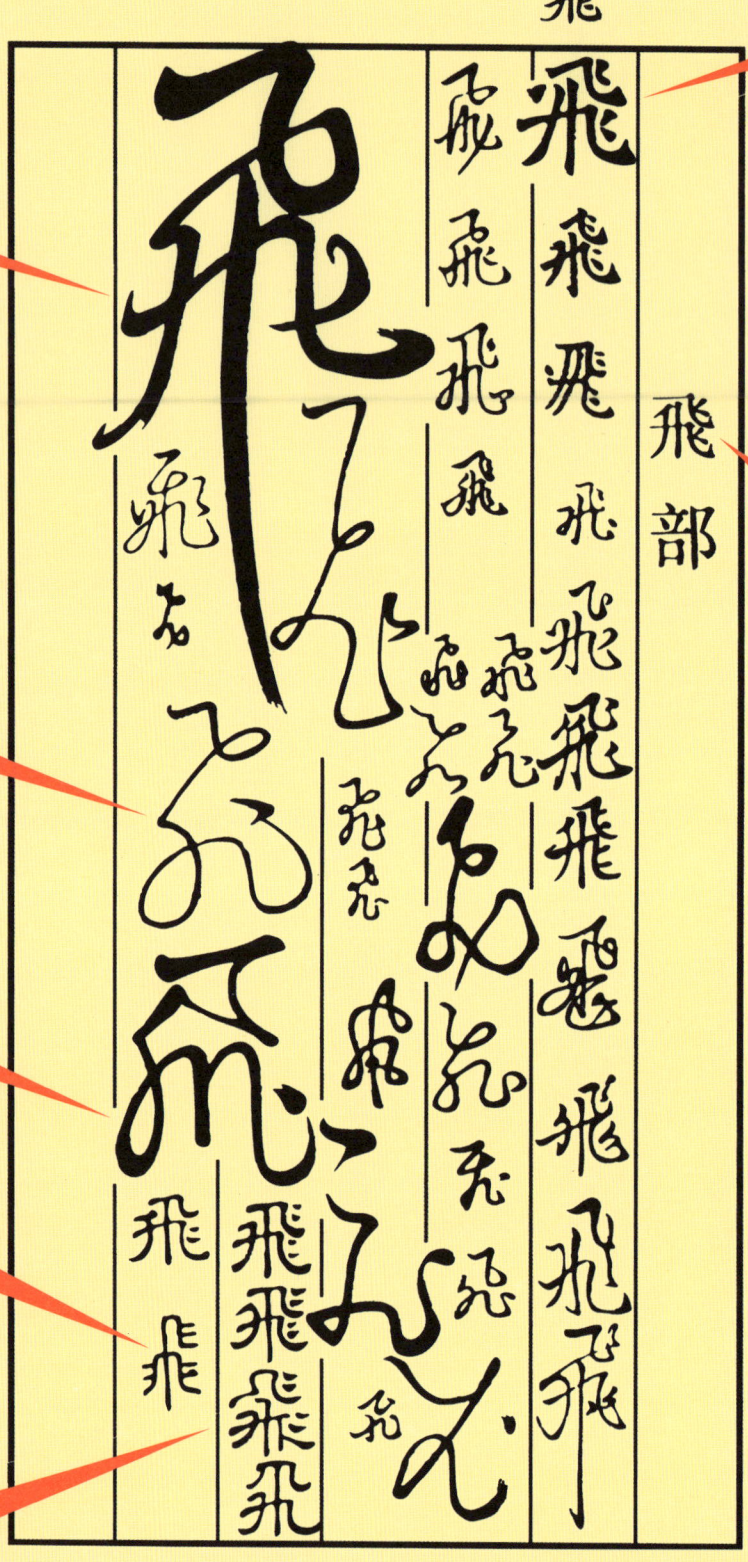

A page of Shufa Zidian, *"The Chinese Calligraphy Dictionary." It contains examples of the best-quality written versions of each character, from all styles and all periods.*

In actual fact, *kaishu* was developed well after *caoshu*. However, it is customary to present them in the order above because its impact and its clarity make regular script the best basic style for learning calligraphy. It is only after assimilating the simpler forms that it is possible to approach semi-cursive and cursive script with any chance of success. But that next step occurs so naturally as soon as the hand and the spirit are deeply impregnated with drawing characters, that it is carried out almost instinctively. It is a sort of automatic writing where your interior self takes the reins.

The masters say that before running, one must learn to walk, which leaves us to assume that we must be starting from an upright standing position! Standing upright, having all the elements well arranged and in order, is the very minimum that a calligraphed Chinese character should do.

Though the five great groups of styles, even seal script, are studied and produced by all advanced calligraphers—and always with a brush—it is obviously cursive script that is considered to be the greatest achievement. It allows a gestural drive that all the teaching has harnessed up to this point in time, and it is the road leading to self expression. However, it's not unusual to see certain masters who, although their work is masterful in more constrained styles such as *rishu*, produce a rather unnatural cursive script that has little personality to it.

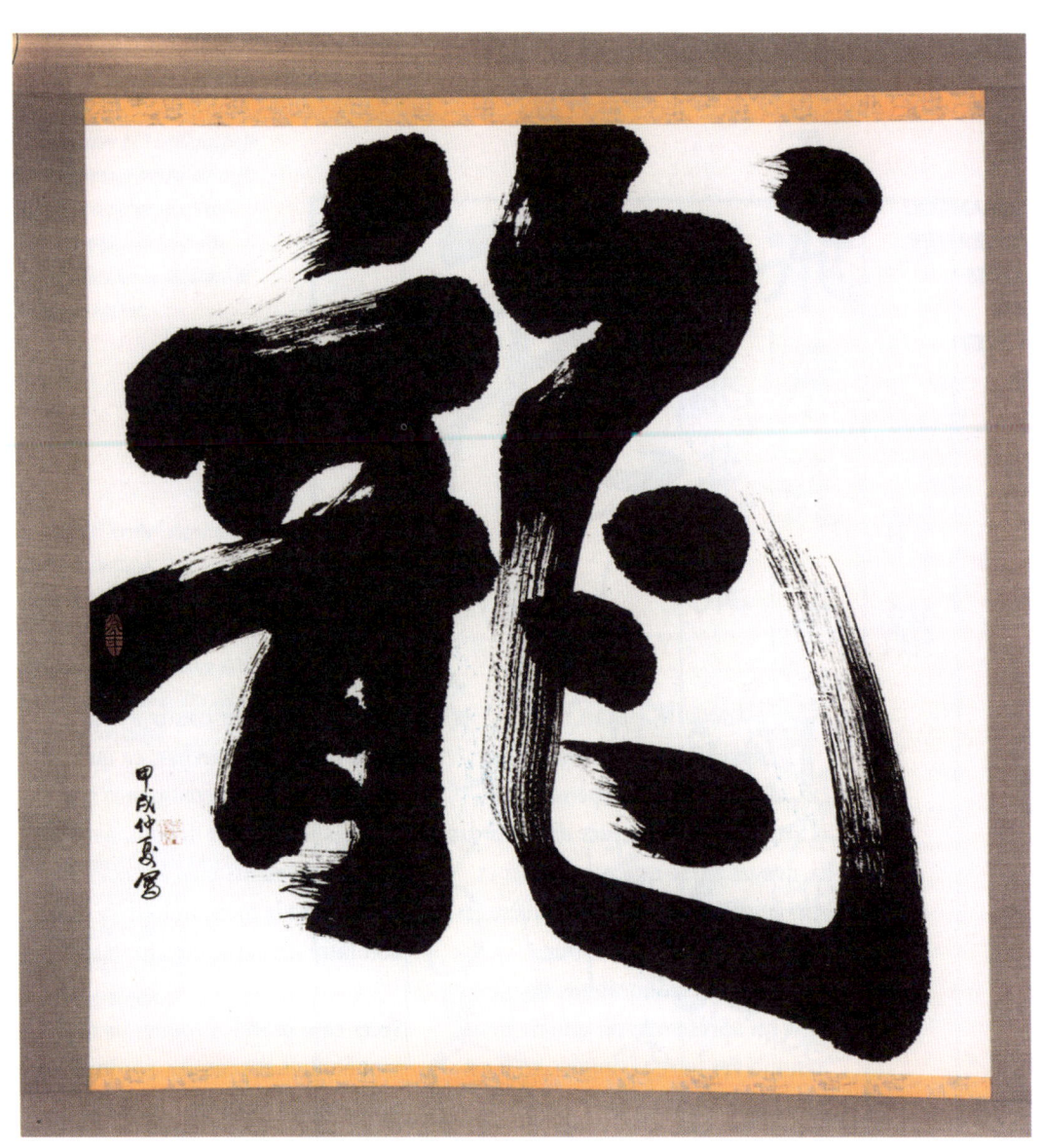

龍

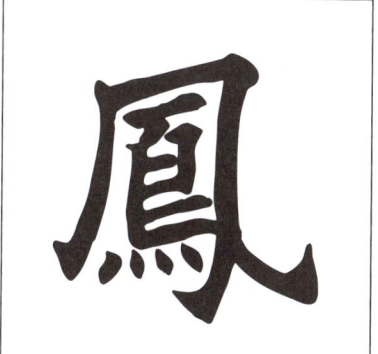

Fourteen centuries separate these two versions, by Ouyang Xun in regular script and by Ouyang Jiaojia in large size cursive script, of the four concepts of the Chinese world. These are the Dragon (opposite page), the Phoenix (above), The Wind, and the Void (shown on the next two pages).

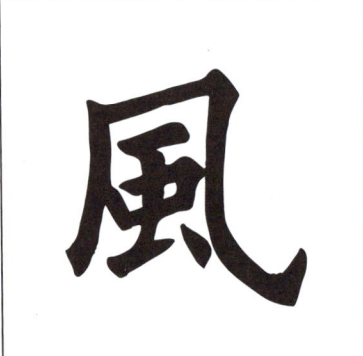

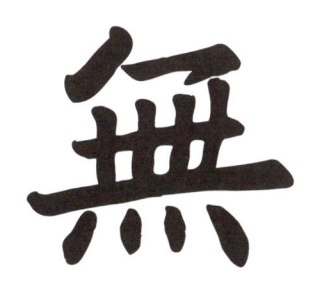

In this representation of the Void (above) Ouyang Jiaojia's large brush casually absorbs most of the lines that make up the character in a strong whirlwind of ink, while the Wind (opposite page) is treated gently, rounding off all the angles.

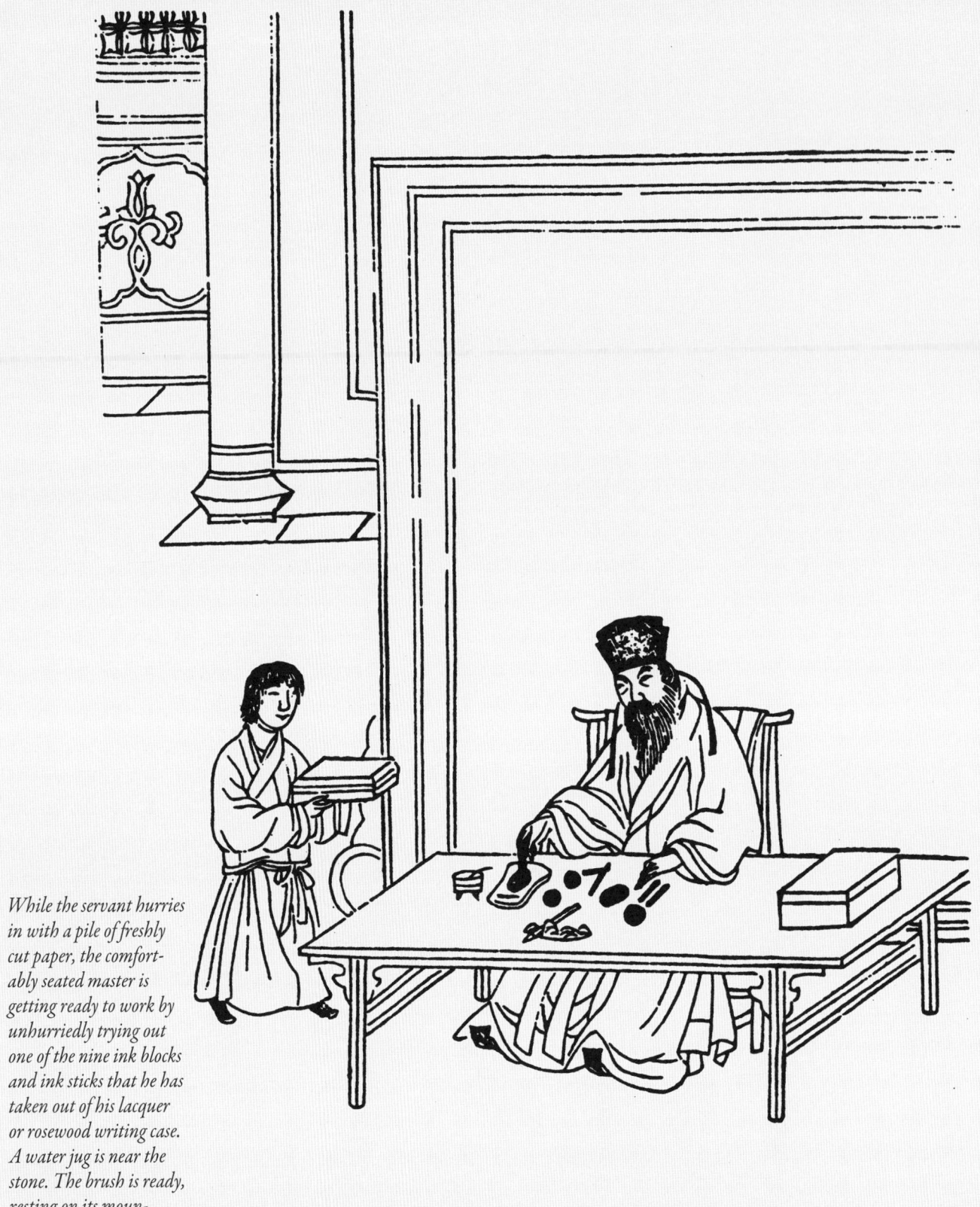

While the servant hurries in with a pile of freshly cut paper, the comfortably seated master is getting ready to work by unhurriedly trying out one of the nine ink blocks and ink sticks that he has taken out of his lacquer or rosewood writing case. A water jug is near the stone. The brush is ready, resting on its mountain-shaped support.

Materials

Four humble natural tools, a calligrapher's treasures

One can learn to write Chinese using a ballpoint pen (or a felt-tip pen, a marker, all those slightly dead things); that can be efficient and useful for memorizing the characters through rapid repetition. However, calligraphy—true Chinese and Japanese script—can't be "knitted together" without four ancient, simple items, sometimes called the four treasures. These are items that traditionally a cultivated person had on hand at home: the dry ink stick, the wet inkstone to scrape the ink stick along, the good-quality brush made of goat hair, and—so sincere—the rice paper.

These tools should only be bought from a high-quality source, because otherwise you risk disappointing results. All imitation materials should be avoided. (We've even run across brushes where the hairs were replaced by hemp!)

It isn't easy for an inexperienced salesperson to recognize the difference between a really usable product and imitation products. The popularity of calligraphy tools as gifts or as decorative objects is such that huge quantities are produced in China, intended for tourists and export. The best way of getting an idea about the quality of the source or shop is to ask lots of questions about the products: their origin, their fabrication, and how to use them. If you're answered without hesitation and without annoyance, you have a good chance of having found someone who is interested in the subject and who can share his or her knowledge with you, because their attitude is more about culture than commerce.

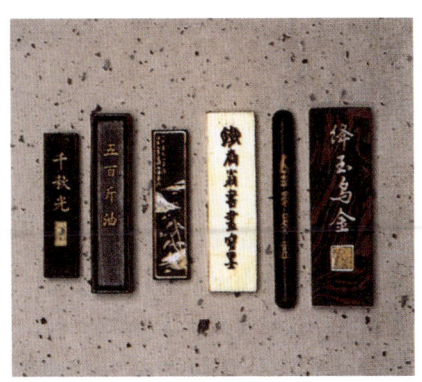

Left to right: Standard ink, oil-based ink, 101 ink, gold-plated 101 ink, oil-based ink made from an ancient recipe, and ink marbled with soot and vermilion that creates an unusual violet-colored script.

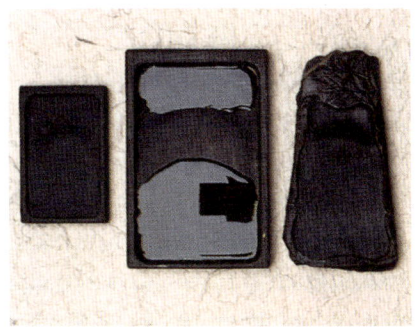

Left to right: A popular good-quality ink stone in two sizes (3⅛ by 4¾ inches, and 5½ by 8¼ inches), and a sculpted Duan stone.

The ink is in the form of a black cake of about 4 inches by ¾ inches, and about ³/₈ inches thick. Gilt ideograms or diverse designs (trees, flowers, animals, or landscapes) are sometimes found on the ink sticks; these are generally just decorations, imitating the ancient ink sticks you can see in museums. A mysterious engraving can sometimes be found on the top of the stick: connoisseurs will know whether the ink is made from aleurite nut, lacquer tree, rape oil, pine oil, and so on. The best Chinese ink sticks have two lines on each side of a circle: the number "101," written horizontally.

This chunk of ink is essentially made from soot and animal glue. Depending on their origin and price, ink sticks produce a more or less black liquid, more or less quickly. There are numerous nuances of black that you will discover little by little as you advance in the art of calligraphy; we mainly distinguish warm blacks and cold blacks (literally "bluish"). The former have a subtle sepia nuance and can be used for wash drawing, while the latter are used by more advanced calligraphers. A beginner should be happy with a middle-of-the-road ink, but it should be remembered that really cheap ink will never produce true black.

Liquid ink, ready to use in its bottle, is practical for an impromptu inscription or an off-the-cuff exercise. It can also be used by beginners for drawing their very first strokes before finding all the right equipment, which isn't often done in one day. However, liquid ink isn't recommended to beginners by the top teachers, who feel that the physical process of preparing the ink for each session is a necessary part of the art. The patient and arduous grinding routine calms the spirit and relaxes the body.

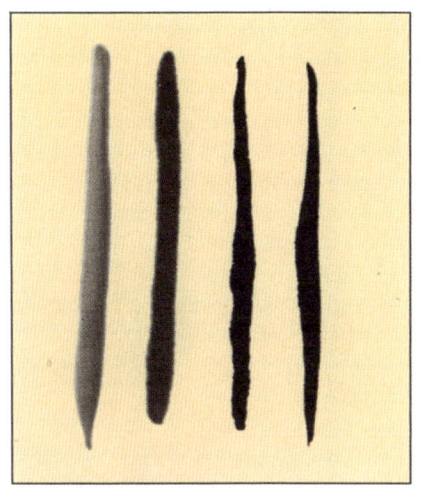

Left to right: These four lines have been made at different points during the process of grinding the ink. Only the strongest concentration of ink, at right, will give a line clean enough to draw Chinese characters. (The more diluted inks are used in traditional painting, called sumi-e *in Japan.)*

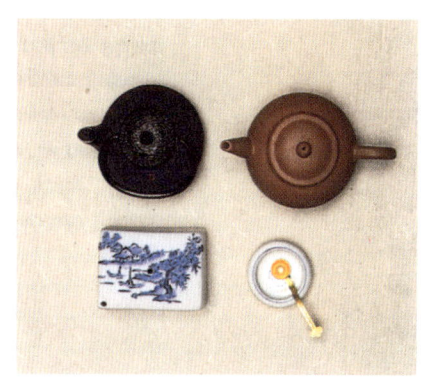

Special jugs are used for pouring the water onto the inkstone and for adjusting the density of the ink. Those shown here look like teapots, and are made of cast iron and terracotta. At bottom left is a Japanese blue and white porcelain "water box" with two holes in the top.

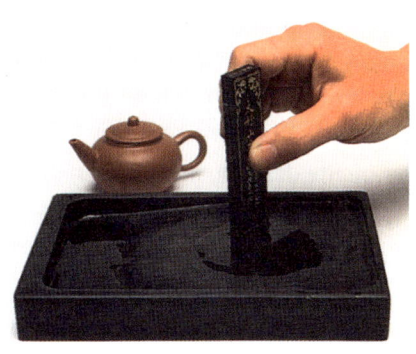

The base of the ink stick is firmly rubbed in round movements on the flat part of the stone, where a few drops of water have been poured.

The inkstone is a rectangular piece of black shale with a flat part and a large hollow part that the Chinese call the "well." After pouring a few drops of water onto the flat part (a special jug is used because any other container, such as a glass or a bottle, has the annoying tendency to cause a flood), we start rubbing the bottom of the ink stick flat on the stone, using firm circular movements, as large as the stone allows. Thus rubbed against the stone's grain, the ink stick begins to disintegrate, and its substance mixes with the water. Once this mixture gets thicker, to the point that it spreads out slowly after the ink stick passes through it, we know that the appropriate degree of black has been reached. We just need to add a little more water and start over again until the well contains enough ink to work with. If the ink in the well is too clear, draw it back onto the flat part of the stone with the ink stick and start the operation over.

Inkstones of all prices are available. Avoid those which are too gray—they are worth a lot less than the prices asked for them! The stone should be black, smooth, and dense. Its grain should finely grind against the ink stick and not make a grainy goo, and it shouldn't be permeable. The best Chinese inkstones are called *Duan* and their color is clearly a purplish black.

Left to right: The same common-quality ink brush shown in three different states: new, badly washed, and dry after washing. A lovely goat-hair brush, followed by one where the wider amount of hair is mounted in a way that preserves its slenderness at the handle. A hubi brush with a rosewood handle. The sable-hair brush with the black handle is used for drawing and small characters. The stag-hair brush on the far right was made in a Shinto temple in Japan and is used for writing minuscule characters.

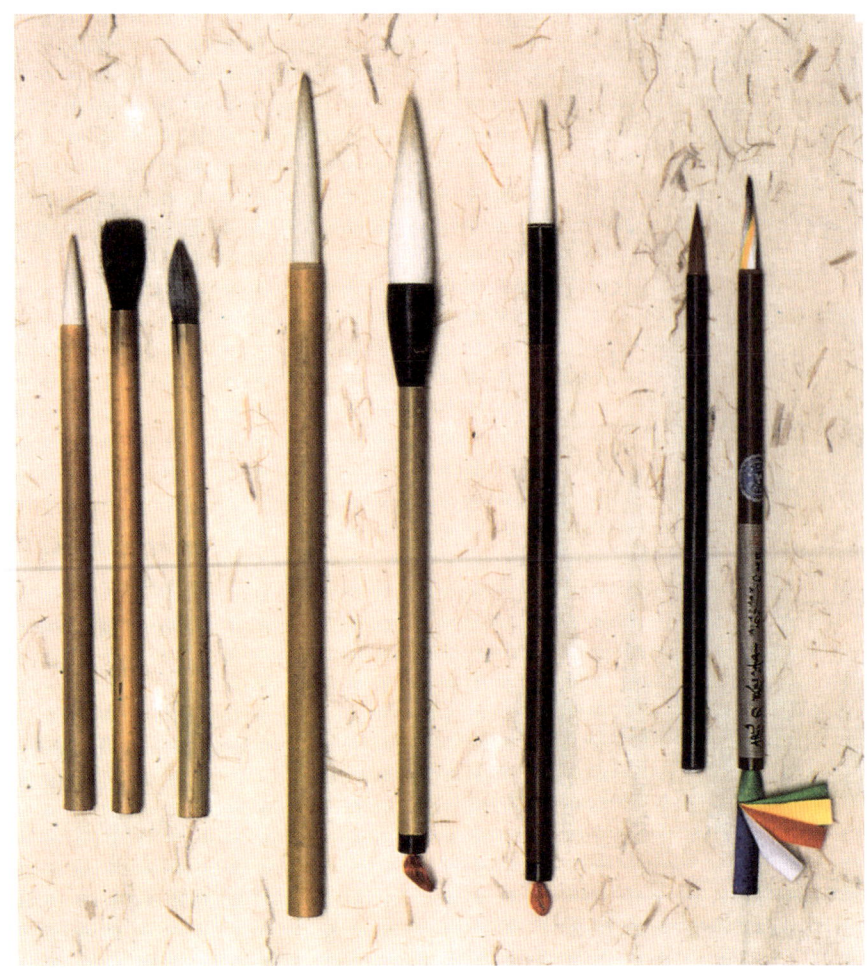

The ink brush is made from a selection of animal hairs (usually goat) that are mounted on a handle ranging from simple bamboo to precious wood.

It is the expert mounting of long and short hairs that gives a Chinese brush the ability to absorb and retain a good reserve of ink, that it releases according to the amount of pressure applied to its tip when in contact with the paper. Thus we obtain a fine and threadlike line or a thick and generous line as required, depending on the letter being drawn.

Thousands of types of ink brushes were—and still are—fabricated in China and Japan. As with the other tools, here too it's best to start off with a brush that's a middle-of-the-road price, which usually means it will have the key characteristics: a good point, good ink reserve, and flexibility.

The ideal size for a beginner's brush should have a head measuring about ⅜ inches in diameter and 1¼ to 1½ inches long. Eventually you'll find that it is best to have several different sizes available, so that you can choose among them depending on the size of the characters you feel like drawing.

Roll-up brush holders made of thin bamboo stems stitched together protect the brushes and let them breathe. Brush supports keep the brush from rolling around; the one shown at bottom left is reminiscent of a mountain chain.

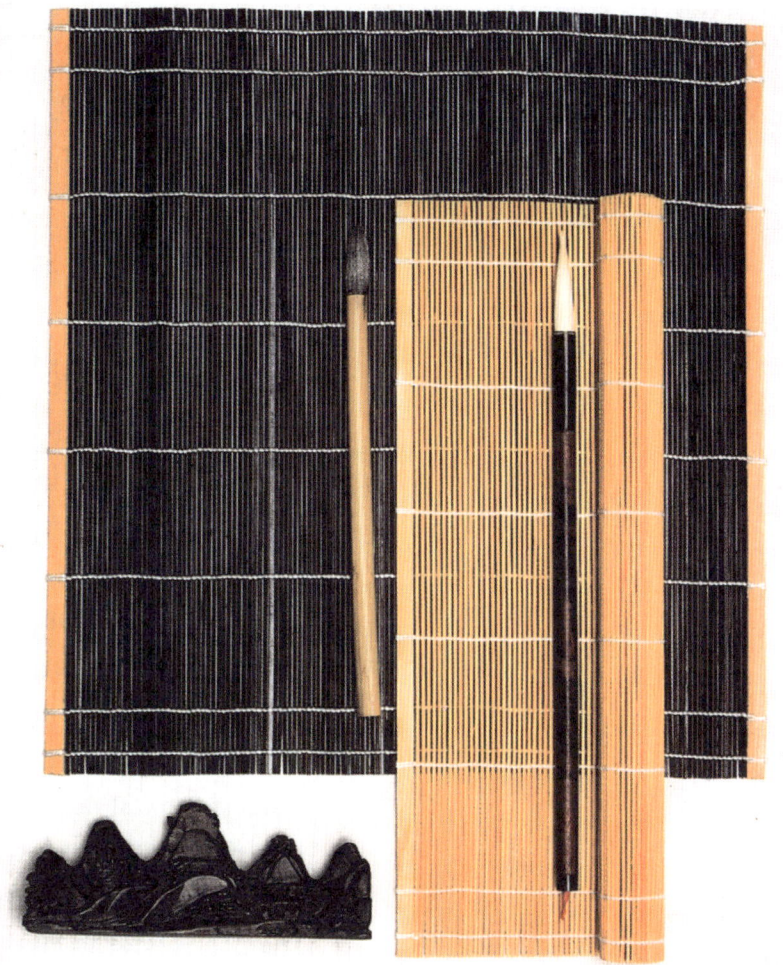

All Chinese or Japanese brushes are sold with their bristles stiffly glued together to keep the hairs from breaking or bending backward, and so that a buyer can quickly judge its shape and size. Before using it for the first time the brush should be washed free of this glue (start by breaking the tip in cold or warm water, and then progressively work on the rest of the hairs until they become supple). Even after that first use, though, the brush should be carefully washed and dried after each subsequent use, to get rid of the glue contained in the ink. If the brush was sold with a protective tube, you can throw this away; you won't be able to get the tuft back into it and you risk damaging it if you try. A brush should be left to dry bristles down, suspended from a special brush stand or from a nail on a board attached to the wall. If you take your brushes with you when you go somewhere, or if you aren't going to use them for a long time, you should protect them in a roll-up brush holder made of thin bamboo stems stitched together. It keeps your brushes safely separated.

An under-sheet with reference marks printed on it: it absorbs the ink and allows the characters to be properly positioned on the paper. Center: A scroll of model characters to copy, whether by tracing over them or freehand. Right: The end of a rosewood paperweight, weighted with lead.

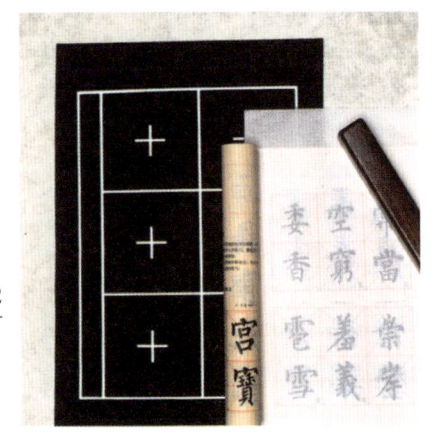

Calligraphy paper is often called "rice paper," although only the best papers are made from dried rice grass and the bark of a species of sandalwood. Crushed, cooked for six hours, left to steep for a month with lime, the fibers are then spread out in a heap on the ground, where they are exposed to the forces of nature for long periods (two years for "old" *xuan* paper). Finally they're put back into a water tank and then are extracted onto a bamboo sheet lifted by two men. The layer that remains on this sieve will become the sheet of paper.

Whether it consists of rice, bamboo, hemp, or mulberry, the paper's long thin plant fibers absorb in just a fraction of a second the glue-soot mix that is the ink, and together they become inalterable once dry. In China, good paper is called *xuan* (*gasen* in Japanese); it comes in several grades, one of which is especially made for practice exercises. It's best to avoid papers that aren't designed for Chinese and Japanese calligraphy (newspaper, tracing paper, wrapping paper, and so on) because even though they may be inexpensive, sometimes even free, there is no way that they will allow you to draw "lasting" lines or to understand this fundamental concept: the speed of drawing. That understanding is vital for making real progress (more on that later). You should also avoid any "mechanically made" papers; they can be recognized by their smooth perfectly regular structure—handmade paper is generally rougher—or by their size: a 30-foot-long roll is obviously produced by machine. You should also know that the major Chinese manufacturers trim the edges of the sheets to make them more presentable and easier to pack, contrary to Western and Japanese manufacturers for whom ragged edges is a sign of "handmade."

Traditional handmade paper is often found in the dimensions of the form that produces the sheets: a little larger than 27 by 54 inches, which are often cut into a dozen pages measuring about 9 by 13¾ inches. You will also find half-sheets sold on a roll, or smaller pieces of paper sold in packages.

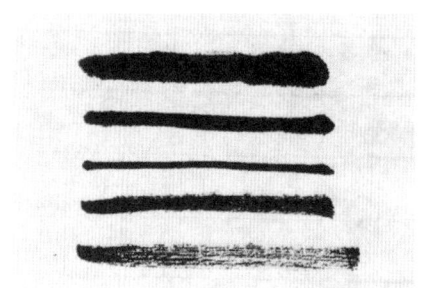

Top to bottom: The same brush with the same amount of ink, but drawing a line faster and faster: The effect obtained in the last line is called "flying white."

Use one sheet at a time because the ink soaks in and blurs. It is recommended to place an under-sheet under the paper to absorb the excess ink. The Japanese have perfected under-sheets for calligraphy by printing boxes on them for reference, to help you position the characters correctly on a blank sheet of paper. You can also trace your own reference marks with a pencil on the exercise paper itself before you begin the exercise. But rest assured—after a while you will get used to structuring the space on an empty page.

The correct speed. Calligraphy paper is made to absorb the ink from the brush, which must learn how to slide and dance rather quickly in certain places so that it doesn't empty the ink in one large thick line. For each paper and each type of ink, you should feel the relationship that's established between the brush's flow and the absorption capacity of the paper surface. All beginners have a tendency to draw each line slowly, which gives the paper the time to suck up the entire ink reserve. Result: the line and then the character are awfully swollen and uneven. On the other hand, as soon as you begin to understand the flow/absorption rate—which happens after a few exercises—you will take advantage of it to get what you want; you will linger here so that the line is large and deeply black, you will accelerate there to obtain natural thinness and lightness. This small game of risk between you, your ink, and your paper is part of the multiple joys that the art of calligraphy offers.

Chinese or Japanese tools?

You should first understand that there is usually very little "specificity": a Chinese calligrapher might use a Japanese brush and vice versa. Calligraphy tools have been made in China for over two thousand years, and nearly as long in Japan. There are stylistic variations, but they are minor. There is often, however, a staggering difference in price, due to the fluctuating value of the yen or the yuan.

The mountains in the Land of the Rising Sun don't seem to have been favored with adequate supplies of minerals, so today all good inkstones are Chinese. But as compensation, Japan enriches the calligraphy kit with technological improvements—like high-precision ink brushes, top-quality conditioned paper, and sophisticated liquid inks.

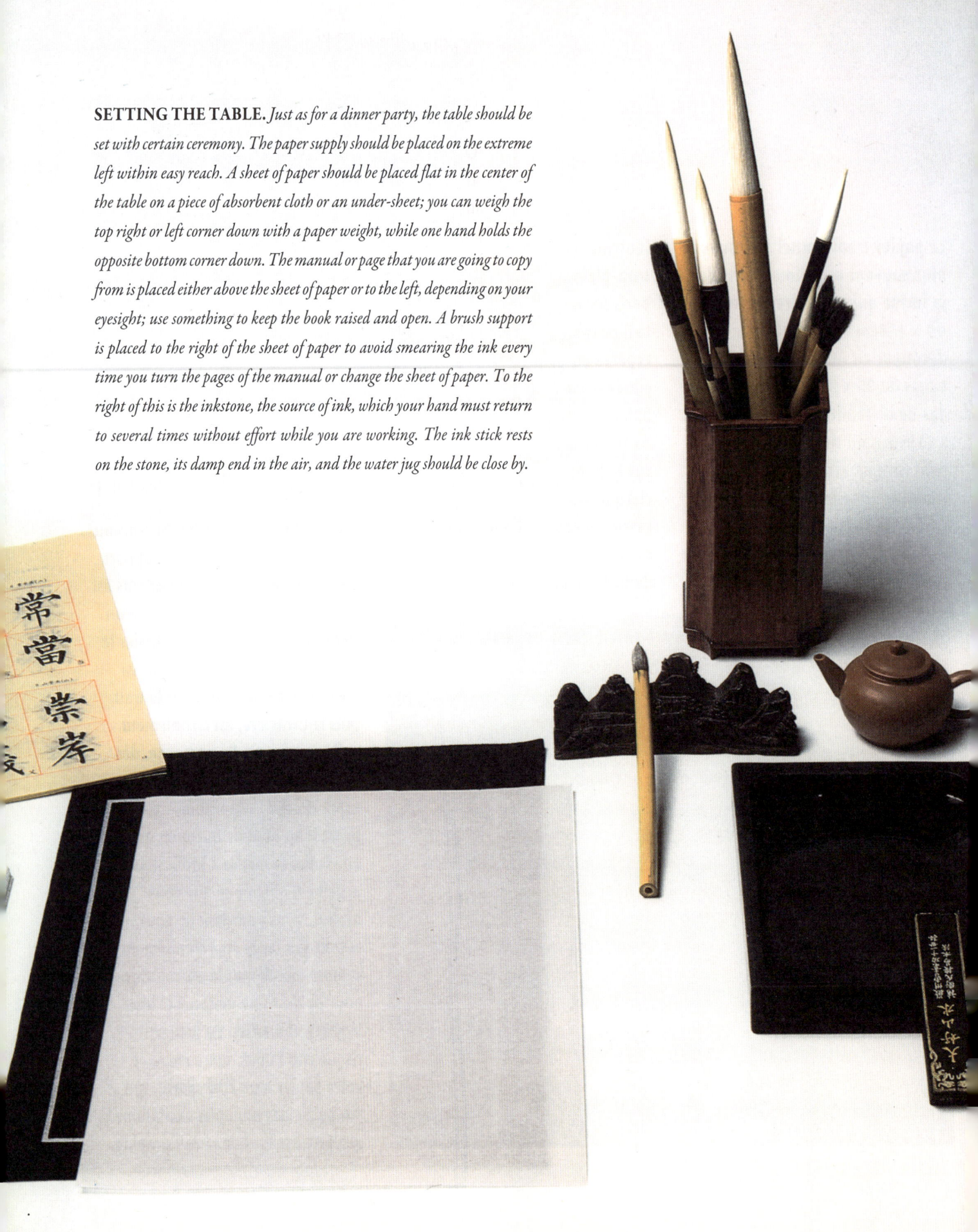

SETTING THE TABLE. *Just as for a dinner party, the table should be set with certain ceremony. The paper supply should be placed on the extreme left within easy reach. A sheet of paper should be placed flat in the center of the table on a piece of absorbent cloth or an under-sheet; you can weigh the top right or left corner down with a paper weight, while one hand holds the opposite bottom corner down. The manual or page that you are going to copy from is placed either above the sheet of paper or to the left, depending on your eyesight; use something to keep the book raised and open. A brush support is placed to the right of the sheet of paper to avoid smearing the ink every time you turn the pages of the manual or change the sheet of paper. To the right of this is the inkstone, the source of ink, which your hand must return to several times without effort while you are working. The ink stick rests on the stone, its damp end in the air, and the water jug should be close by.*

How to Start

Movement that feeds on stillness

Chinese and Japanese calligraphy's worldwide success comes, of course, from its unequalled beauty and the mysterious forms it creates, from the richness of its history and the possibility to constantly innovate its styles. However, there is another, hidden reason that so many people wish to practice it and sometimes get attached to it forever: it is an activity where the whole body is involved, and which brings physical and mental benefits, an immediate feeling of well-being.

The price to pay for these advantages is to completely understand and apply the rules.

First of all, organize your work space. You need a calm room that is rather well-lit, ventilated, and which is always the same—at least during the beginning period of your studies in calligraphy—so that you can quickly get into the right state of mind. You should practice frequently, even if if only for short periods (ten minutes is sufficient as long as you practice several times a week); so it is a good idea to have all your material at hand, ready to use.

Then, make sure everything is balanced: the table and chair should be at the same height as your dining table and chairs are. Sit up straight without leaning against the back of the chair and without your stomach touching the table, legs slightly apart, feet parallel and flat on the floor. Now, with your left hand placed on the bottom of the sheet of paper, your right arm and hand are free to move without support, to move with flexibility using all the energy of your body, which is settled and ready.

By channeling the energy of your entire body toward the tip of the brush you will be able to pilot it as you wish and give it the force or the lightness desired: your back will support your arm, and your elbow will keep your hand suspended in the air.

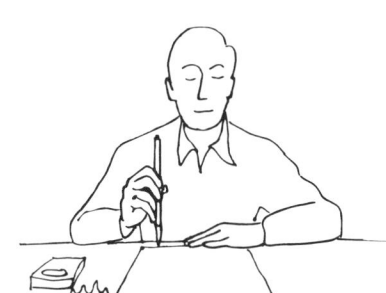

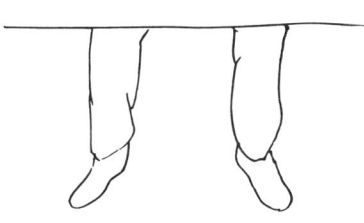

Contrary to popular belief, the calligrapher's hand does nothing but hold the brush; the movements come from the shoulder and elbow. The *way* of holding the brush, on the other hand, is very important.

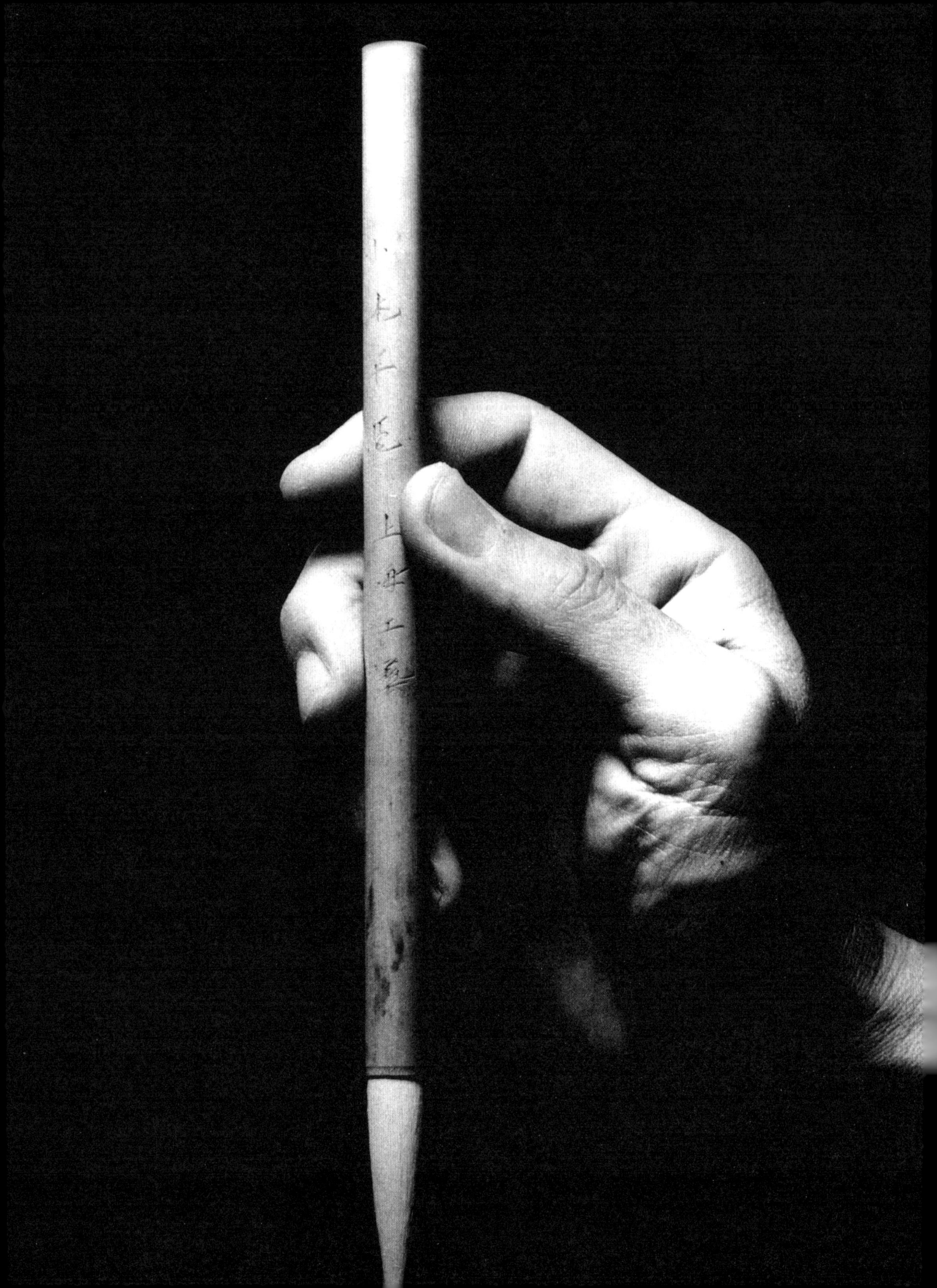

Holding the brush

1. Hold the brush in the middle of its handle, with your thumb on one side and your forefinger and middle finger slightly bent on the other side.

2. Place the back of the first segment of your ring finger about ½ inch below your thumb, so it can exercise pressure in counterbalance to the middle finger.

3. Place your little finger against your ring finger to give it support.

4. Create a hollow in the palm of your hand (big enough to hold an egg). Make sure that there is an opening between your thumb and index finger (this is the tiger's mouth).

5. Bend your wrist until your hand forms an angle of 45° to your forearm. The brush should be perpendicular to your forearm.

6. In this position of attack, your wrist should be on the same level as your elbow.

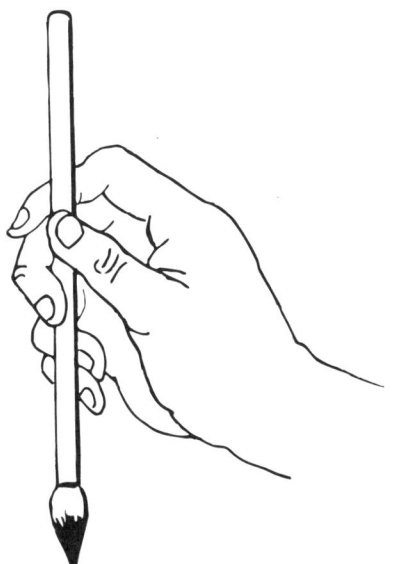

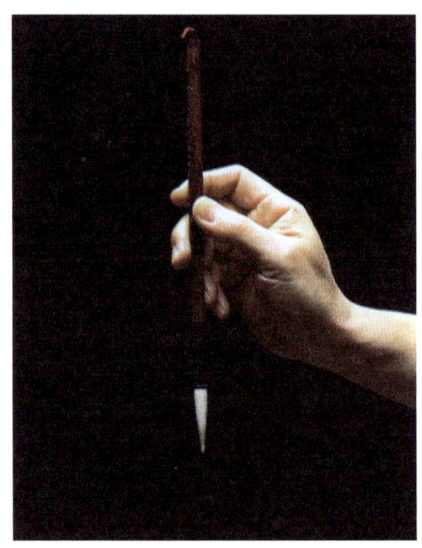

This is the hand's position, and it is the only correct one.

Obviously, it might seem to be difficult and uncomfortable at first: your wrist will hurt a little and you might ask yourself how you are supposed to write while holding the brush more like a dart than a pen! But you will quickly realize that this way of holding the brush is firm without requiring effort and that it is the natural outcome of the position of your entire body.

Holding the brush in the center and in the described position is convenient for medium-sized lines, which are the ones you will be doing for a while. With time, you will be able to draw smaller and smaller characters and only then will you be able to rest your elbow on the table from time to time. But only lines that are less than one centimeter long, in the sutras, for example, are drawn with your forearm resting on your left hand.

Your hand doesn't move, because your arm is working for it: your elbow goes back and forth while your forearm pivots round the elbow and rises and lowers over the paper.

Reread the last paragraph carefully and make your arm do the three movements described: you will see that their combinations allow your hand infinite movements.

There are three results of these movements, three touches and pressures of the brush:

—Only the extreme tip touches the paper (known as raised brush).
—The tip is slightly bent on the paper (applied brush).
—The tuft is strongly applied as if to pierce the paper and the table (flattened brush).

These different types of contact between the hairs and the paper only exist in combination with movements in precise directions—without that, you will only get a lot of splotches!

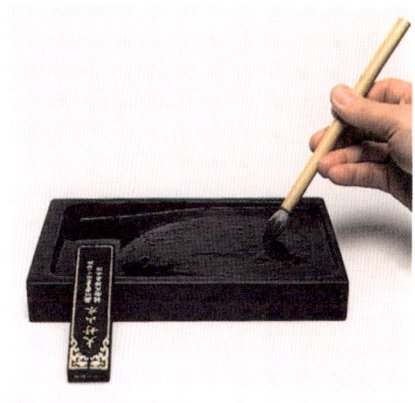

There are only four directions:

—From left to right.
—From top to bottom.
—Diagonal from the top right to the bottom left (called left-falling).
—Diagonal from the top left to the bottom right (called right-falling).

There is one exception: the tip makes a (very short) movement from right to left or goes up in only two cases:

—To "sculpt" a dot or a line, as we will see.
—To achieve a line or a dot with an exterior point, called a "hook."

Remember that "raised" and "applied" indicates the vertical movement of the brush over the paper, while "upward" and "downward" means that it moves toward the top or the bottom of the paper in constant contact with it. The verb "break" is often mentioned in the description of the brush's movements; it means the abrupt changes of direction, by turning, even almost reversing.

It is essential to realize how each fundamental element—called "line" or "dot" to simplify matters—is made up of an attack and an ending, subject to precise rules. It is the quality of this beginning and this conclusion that determines the element's form; the middle part could almost be considered to be their connection.

A precept to remember: the hairs of the brush should remain straight and well aligned toward the tip. If you as a beginner "get twisted" at the end of a character, meaning that the tuft remains twisted at the end movement, you should take time to smooth the tip out on your inkstone before attacking the next stroke. (This is why rectangular stones with a flat part are better than those that only have a hollow part; the latter are best used when preparing large quantities of ink in advance, or to hold liquid ink.)

To fill the brush with ink, load the ink on one side of the tuft and then on the other side so that it is filled equally. Smooth the tip to get rid of the excess. This reserve of ink should normally be sufficient for several characters. This depends on how you master the flow, which will get better with time. However, you should know that it is better to finish a character before refilling the brush because otherwise, you break the rhythm of its creation and thus its harmony.

方	小	太
十	二	百
上	下	巾
力	月	午
人	木	是

Exercises

A dot plus a few lines, that's all

Isn't it strange: a handful of lines are enough to make up the hundred thousand characters that the Chinese have invented over the centuries!

Depending on the number of lines (or "strokes") that make up a word—one may have more than twenty strokes—the lines are squashed together like toes in a too-tight shoe, or instead might stretch to take up a lot of space. But no matter how they are arranged for a certain character, these basic strokes are the elements of all characters.

We should make them our friends: examine them carefully, recognize them, and learn how to form them without effort to finally construct the characters of which they are the ingredients.

The number of basic strokes can be reduced to nineteen for the purposes of this book. These nineteen are quite sufficient for a good start in the art of calligraphy. (That said, the number isn't much higher even in Chinese school students' lessons, but there all the variants are classed as strokes.)

To make memorizing them easier and so that you can quickly pass on to practical exercises with real words, we are going to work in two waves:

—The first nine strokes, the simplest, immediately followed by exercises with the characters that they can form.
—A second series, made up of more elaborate elements; these will allow you to expand.

Each of these elements has a name and a number. You will quickly learn them by heart, as they are repeated in the descriptions of the characters a little further on as well as in the summary table on page 53.

You shouldn't confuse these graphic components, which are the fundamental elements, with the "keys" of the Chinese language, or "radicals," which are already complete characters, incredibly old, around which the entire Chinese dictionary is organized. (See the box on page 68.)

Each stroke has its rules, its ductus. They will be shown in a diagram, where the central line shows the way and the direction that the tip of the brush should follow, and the exterior form shows the desired result. Steps (a, b, c, and d) correspond to the moments of making the lines, and are described in the text. That is where you will find the instructions on the brush pressures to be applied.

Dot toward the right / # 1

(a) Attack with the tip, descend toward the right, simultaneously turning and applying the brush to get more thickness (b) and go back toward the top (c). Lift the brush when you reach the center of the dot.

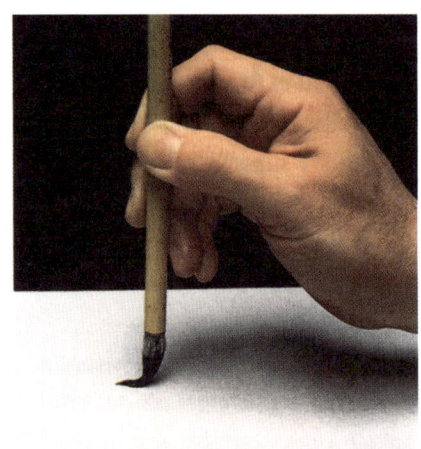
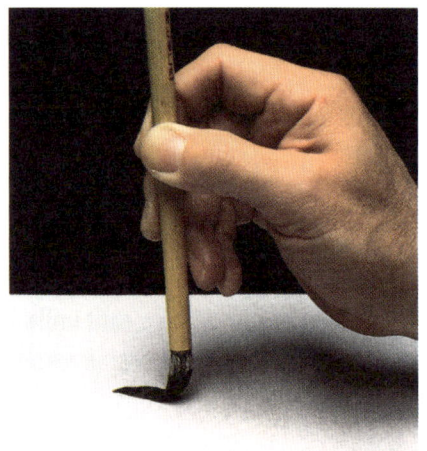
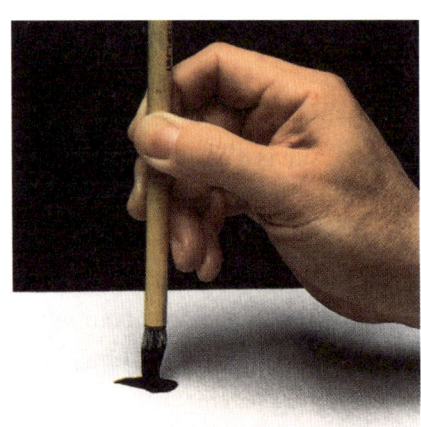
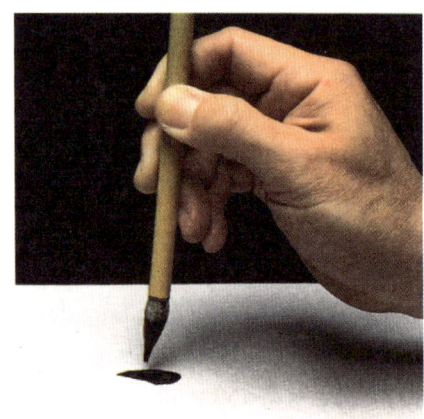

Dot toward the left / # 2

This explanation is long if you compare the time it takes to do a dot: about half a second! The whole movement of the brush on a tiny space consists of erasing the tracks of the hairs and "sculpting" a clean shape that looks like a pebble.

The size of the dot is a function of the width of the brush and, obviously, a function of the artist's experience. Your first dots will naturally be too big because you are trying to follow the ductus, and when done too slowly, dots have a tendency to drip and the ink gets soaked up in the paper and drowns the form you are so meticulously trying to create. Don't worry: the same thing has happened to everyone as they learn, Chinese and Japanese children too! So, get to work: do hundreds of dots on the same page until you can reduce their size to three-quarters of an inch, and then to half an inch; and until their shape is clean and vigorous, and their color is a deep black.

You should date the pages of this first exercise, and of all the following ones, and set them aside to keep; starting as soon as tomorrow or next week, you'll be surprised at the progress you have made.

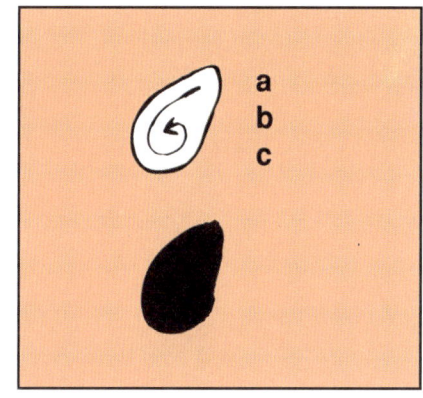

The movement is the same, but inverted.

—Do a page of exercises until there is a clear improvement.

—Redo a few dots toward the right (stroke #1).

—On a new page, alternate the two.

Horizontal stroke / # 3

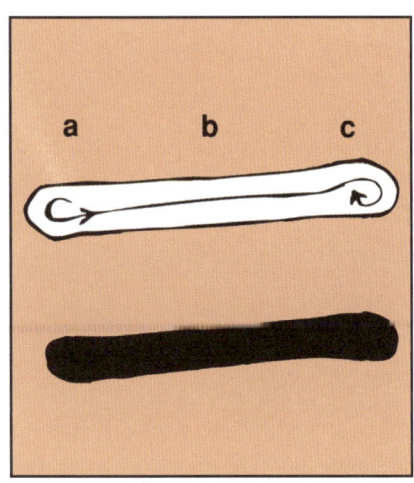

The horizontal line is easier to do and you should quickly be able to line up a dozen or so, each measuring about 4 inches long with a half-inch thickness, then 2 inches long with a quarter-inch thickness. With this element being easy and the dot being rather difficult, the next exercise consists of alternating a column of one and a column of the other.

When you feel at ease with the mechanics of each line, practice doing different lengths (from ¾ to 2½ inches), because once we reach the complex characters you will find the size of the lines is inversely proportional to their number; the space (the square area for each character) stays the same no matter how many strokes it has. If you have to place a dozen strokes, you would do them smaller than if the character only had three or four.

(a) Attack with the tip and move toward the left, applying the brush and turning twice, and turn back toward the right raising the brush to do the central part (b) quickly. (c) Apply the brush slightly and turn twice to return toward the center while lifting the brush.

We call this last movement "returning the tip into the line." Just as the attack does, it serves to erase all traces of the hairs and leave a superb object that is fine, robust, and deep black on the page, a work that looks like the bone from a strong animal.

Note that the horizontal line isn't rigidly parallel to the edge of the page: it clearly rises on the right side. The life and dynamism of good calligraphy is based on this sort of imperfection.

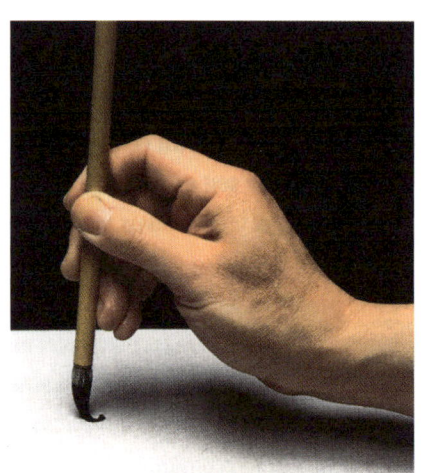
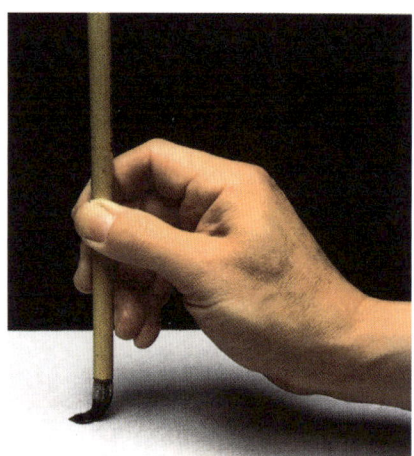
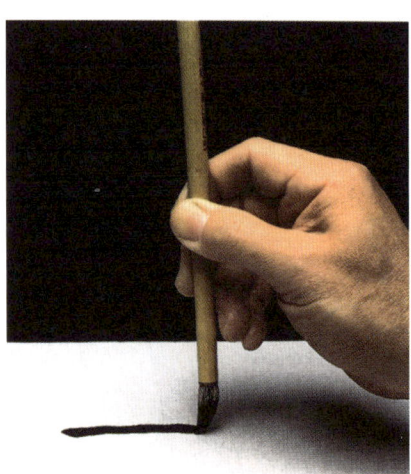
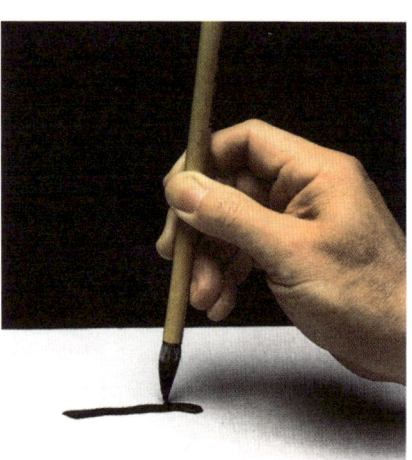

Flat hook / # 4

(a) and **(b)** proceed the same as for #3. **(c)** Instead of returning the tip into the line, stop the movement at the last moment and bring out the tip of the brush lifting it slowly.

To do a successful hook, the secret lies in not interrupting the movement of the brush toward the outside, even when the tip is no longer in contact with the paper.

Vertical stroke / #5

(a) Attack toward the top, apply the brush, turn twice and lift it while descending. **(b)** Descend straight. **(c)** Apply the brush and return the tip into the line.

The difficulty with this element is descending straight. You will only succeed if your elbow does it and not your forearm, which would draw in diagonal, and without twisting your hand, which would modify the thickness of the line. Now go and do some pages of exercises!

Vertical hook / #6
Suspended needle / #7

The vertical hook / #6

(a) and **(b)** are the same as for the vertical stroke (#5). **(c)** Apply the brush and turn up toward the left and then come out on the side lifting the brush.

The secret of doing the flat hook / #4 correctly also applies here.

The suspended needle / #7

(a) and **(b)** are the same as for the vertical stroke (#5). **(c)** Descend and progressively lift the brush, but don't finish with a too-pointed tip.

Left-falling stroke / # 8

(a) Attack toward the top then rapidly turn twice and go in the opposite direction, toward the bottom left. **(b)** Descend curving the line slightly, slowly raising the brush halfway along. **(c)** Continue the movement lifting the brush. This end should be very pointed.

This line in the shape of a dagger is one of the most beautiful and characteristic of Chinese script, where it is often found in different lengths, or even reduced to a dot (see the illustration below). It is easy to do; work on the curve and above all its ending, which should contrast with its thick, bony head.

Right-falling stroke / #9

(a) Attack toward the left then turn twice and come back toward the bottom and toward the right. (b) Start to apply the brush while curving the line. (c) Flatten the brush accentuating the movement toward the right, and then lift the brush to make a point.

This element should look like a scimitar. There is no short variant, but it is also found more or less slanted, and even almost flat.

Without knowing it, you have already written your first Chinese character several times: the number 1 is made up of a simple horizontal stroke (#3). It is pronounced *yi*.

Now let's move on to the first exercises with characters.

丶一フ丨丨丿乀

Strokes #1 to #9.

REN

Here you are, rich in experience in drawing the nine strokes, because you have repeated them hundreds of times. If the results of your work are very different from the model it shouldn't bother you; that's only due to a lack of experience. The answer is simple: each time you sit down to practice, do each of the previous strokes you've learned a dozen times before starting to learn new elements. You will be happy to notice that you'll find it easier each time, and your results will be better than your last ones, as if your inner being has somehow assimilated what you found so tiresome at the time.

Let's approach the combining of some strokes, to create several basic characters. The following pages are characters made up of the strokes you already have down pat.

A human being is made of only two pieces: the strokes #8 and #9, articulated by the head of #9, which starts inside the former at about a third of the way down the line. Thus we have the sensation of seeing a person full of drive who goes through his or her existence with determination.

For each of these examples, note the position of each line in relation to the box's center point (where the guidelines cross). To be properly proportioned each ideogram should be inscribed in an identical imaginary square; it's not the case that this character should be small because it only has a few lines. And since you will soon be writing sentences, you have to learn not to be afraid of leaving white space around simpler characters.

人

丶一一﹁丨丨八

Strokes #1 to #9.

TIAN

Two horizontal strokes (#3) and then the two lines of *ren* to make "sky"—*tian*.

The first of the horizontal strokes is clearly shorter to give a visual equilibrium. They slant slightly upward; if they didn't the effect would be heavy. Study how these four lines articulate, where they start, and where they finish.

Observe the stroke order of each character, which is shown in each diagram. This sequence is very important, first of all because it determines the form and the size of each line following, and it helps you to memorize the whole thing. Second, because it is this sequence of linking that naturally guides the gestures of cursive calligraphy, a major art that your efforts today are leading up to.

天

丶一フ丨丨八

Strokes #1 to #9.

XIAO

If we had left out the first stroke of "sky"—*tian*—we would have written the adjective "big"—*da*. Here is its opposite, "little"—*xiao*.

Xiao is easy to draw if we boldly place the pieces in the empty space of the page. *Xiao* is made up of a vertical hook (#6) with a dot on either side—a #2 dot toward the left and a #1 dot toward the right, which finishes the word.

Once you have mastered this, repeat the character *xiao* several times, accelerating your speed each time. That will help you to find another component of calligraphy: rhythm, and the pleasure of a balanced gesture.

小

丶一一川八 　　　　　SHUI

Strokes #1 to #9.

水
一 ノ 小 ノ 八
₃ ₈ ₆ ₈ ₉
丨 丬 才 才 水

Five brush strokes write *shui*—"water." First draw the vertical hook (#6) carefully positioned in the center and then add a short horizontal stroke (#3) on the left about a third of the way down. The left-falling stroke (#8) starts from there. Your hand then goes to the opposite side to draw a second, much shorter line, whose point ends in the central stem. Finally the brush starts again in an imposing stroke that descends to the right (#9).

水

Rising dot / #10
Right-hand hook / #11

This SECOND WAVE of strokes (#10 to #19) will give you all you need to be able to draw the most common Chinese characters.

Rising dot / #10

(a) The tip descends and the brush is applied. **(b)** Do an almost complete turn and go back up, lifting the brush.

The rising dot is one of the rare brush strokes that goes upward, and it is also very short. You will mainly find it in a combination with two dots toward the right (#1), which are placed above it; we call this "three drops of water" and it is one of the most common radicals. (See page 68.)

Right-hand hook / #11

(a) and **(b)** are the same as the vertical #5. **(c)** The point turns abruptly toward the left and then toward the bottom and rises in the same way as the rising dot. Lift the brush.

The four elements #11 to #14 are actually combinations of the strokes you already know. They are completed in one single stroke and they count as a single stroke. (This kind of information is good to know, since Chinese dictionaries are organized by the radicals and the number of strokes.)

Broken line / # 12
Broken hook / # 13

Broken line / #12

Broken hook / #13

(a) Like the horizontal stroke #3. **(b)** The tip breaks four times its length to obtain a good exterior angle. **(c)** Like the vertical stroke (#5).

(a) and **(b)** like the broken line (#12). **(c)** Like the vertical hook (#6).

Enveloping hook / #14
Halberd hook / #15

Enveloping hook / #14

Halberd hook / #15

(a) and **(b)** like the broken hook (#13). **(c)** Curve the vertical part and finish with a hook.

(a) Like the right-falling stroke (#9). **(b)** Without hesitation make a curve, with a raised brush. **(c)** Apply the brush and "break" the movement and then go back up toward the top and lift the brush.

The name of this stroke comes from an ancient Chinese weapon.

Heart-hook / #16
Dragon's tail / #17

Heart-hook / #16

(a) The tip goes up to the left and then reverses without being applied and heads toward the bottom right **(b)** to finish **(c)** like the halberd hook (#15).

This stroke (a simple variant of the preceding one) is called this because it is used to write the word "heart" and its variants.

Dragon's tail / #17

(a) Like the vertical stroke (#5). **(b)** Turn to form a gentle right angle. **(c)** Like the preceding strokes.

This element is the last character of "dragon," hence its name.

Broken oblique line / #18
Ear-hook / #19

Broken oblique line / #18

(a) The tip goes up, "breaks" to the right and then descends toward the left, lifting the tip slightly. **(b)** Halfway down, the tip changes direction toward the bottom right with a slightly curved line. Apply the brush before the end and enter the tip into the line.

Ear-hook / #19

(a) Like the broken line (#12), very compact and then the tip heads slantwise for the left, slightly lifting the brush. **(b)** "Break" and go back toward the bottom right, applying the brush. **(c)** Like a small enveloping hook (#14).

Summary table of the 19 basic strokes

First wave			Second wave		
1. Dot toward the right	`	pg. 32	10. Rising dot	ノ	pg. 48
2. Dot toward the left	`	pg. 33	11. Right-hand hook	レ	pg. 48
3. Horizontal stroke	─	pg. 34	12. Broken line	７	pg. 49
4. Flat hook	⌐	pg. 35	13. Broken hook	７	pg. 49
5. Vertical stroke	│	pg. 36	14. Enveloping hook	７	pg. 50
6. Vertical hook	┘	pg. 37	15. Halberd hook	ﾉ	pg. 50
7. Suspended needle	│	pg. 37	16. Heart-hook	ﾚ	pg. 51
8. Left-falling stroke	ノ	pg. 38	17. Dragon's tail	し	pg. 51
9. Right-falling stroke	＼	pg. 39	18. Broken oblique line	く	pg. 52
			19. Ear-hook	ろ	pg. 52

丶丶一一川八ハルフフつししく3 # YUE

Strokes #1 to #19.

You now know enough strokes to approach complex characters. Nevertheless, we will advance step by step and start by learning simple words that don't have too many strokes. We will use the moon as a first example.

月
₈ノ ₃一 ₃一 ₁₃コ
ノ 刀 月 月

YUE, the moon, is composed of an almost vertical stroke descending toward the left, a broken hook with a very short horizontal part, and two even shorter horizontal lines on the interior. It is customary that these latter touch the left-hand stroke but stop short of the right-hand stroke.

丶丶一一川入ヘル﹁﹁冂乚し く ろ

Strokes #1 to #19.

YOU

*The following example shows how the limits of the space harmoniously changes the strokes, without changing their order or their ductus.**

YOU, the verb "to have," is made up of a horizontal stroke, crossed by a left-falling stroke, against which a complete *yue* ("moon") is attached; this *yue* is obviously twice as small than it would be written on its own. Also note that the left-falling stroke has been replaced by a vertical stroke.

有
一 ノ ｜ 冂 一 一
 3 8 5 13 3 3

一 ナ 大 右 右 有 有

*Ductus: the guide or method that separates a character into as many strokes as necessary, indicating each one's sequential order and direction.

PENG

Strokes #1 to #19.

PENG, "a friend," equals two moons. And naturally, you will have to close up the horizontal strokes so that this composition occupies its space harmoniously.

Your growing understanding and practice with this plasticity of the strokes will help you feel comfortable re-doing your early exercises, and will help you to estimate the empty space waiting for your brush strokes.

`、丶一ー｜川八乂儿フㄱ乁乚㇄く乙`

Strokes #1 to #19.

WEN

WEN, "culture," starts with a dot, which is followed by a horizontal stroke (always slightly ascending). Next, a left-falling stroke, crossed by a right-falling stroke. See how the assembly of these four very simple elements immediately constructs something that is both solid and alive, a closed place that seems to be in movement.

Exercise: Study the following words, which are similar to *wen*.

齐纹雯

开	门	走	马
见	山	观	花
画	龙	杯	弓
点	睛	蛇	影

Chengyu: Four-Character Phrases

Both an amusing story and a handy exercise

A fruitful practice of Chinese calligraphy is only possible (and enjoyable) if we understand what we are writing. With these exercises, instead of writing isolated words we'll approach what in China is called *chengyu*.

Chengyu is a proverbial phrase, a phrase of four characters that has passed into everyday speech and is used by people instinctively as part of conversation. It summarizes a whole story, usually very old, that everyone understands. (A person who only speaks English will earn kudos from the Chinese person they're speaking with, if they can drop a *chengyu* correctly into the conversation.)

So here is a series of four *chengyu* of increasing difficulty, with all the instructions you need to create them with a brush, and at the same time understand their meanings.

For each, the four characters are set out here in "Western" reading style, that is to say, in two lines that are read from left to right, top row then bottom row. But we could have written them in the Chinese way: in columns, read top down, moving from the right column to the left column.

Start by drawing each character separately, as you did for the earlier exercises, until you can draw them from memory. Then draw the entire *chengyu* on a single page, like the model shown.

FIRST CHENGYU:
Kai men jian shan

Open the door and see the mountain.

1. KAI. "Open." Do two horizontal strokes, a left-falling stroke, and a vertical stroke.

2. MEN. "Door." Start with a dot, and then a vertical stroke followed by a broken hook.

3. JIAN. "See." Vertical stroke, broken line, followed by a left-falling stroke and a dragon's tail.

4. SHAN. "Mountain." A vertical stroke and then another on the left, linked by a horizontal stroke and a vertical stroke on the right. Notice how the horizontal stroke slants slightly upward.

When you're finished working on the words separately, draw the four of them together, as seen in the model.

开门见山

Open the door and see the mountain. The expression dates back to a book in the Song dynasty, where a commentator said of the poetry by the great Li Bai: "Just as the door opens we discover the mountains." Today it more or less means "cut to the chase" and "look reality in the face instead of getting lost in theories."

The official method for transliterating Chinese into English characters is called *pinyin*; it is quick to learn, and it allows students from all over the world to pronounce Chinese syllables (we'll leave the tones, another essential part of the pronunciation, aside for the moment).

SECOND CHENGYU:
Zou ma guan hua

Look at the flowers while passing by on a horse.

1. ZOU. "Go." A short vertical stroke cut by a first horizontal stroke, not much longer; a second horizontal stroke underlines it. A vertical stroke below this latter with a short horizontal stroke in its center. On the left draw a small left-falling stroke, from which you will draw a slightly slanting right-falling stroke that the whole character sits upon.

2. MA. "Horse." A broken line, followed by a vertical stroke and then an enveloping hook with a horizontal stroke not quite touching it on the left.

3. GUAN. "Look." This is made up of two characters. The first is done with a short horizontal stroke joined to a left-falling stroke, which it crosses with a long dot toward the right. The second is *jian*, which you have learned on page 60, but which you must compress so that it takes its correct place in this new word.

4. HUA. "Flowers." Start with the two small crosses on the top (grass radical, "when passing"). Vertical stroke cut by a horizontal whose ending is left suspended while once again drawing a left-falling stroke, and then a horizontal stroke. They are both very small. Beneath them, a left-falling stroke and a vertical stroke. Another left-falling stroke that crosses a dragon's tail. This is the flower, or flowers, depending on the context.

走马观花

Look at the flowers while passing by on a horse. This derives from an old Chinese joke about subterfuge: matchmakers arranged that, for the first date between a cripple and a girl who had an ugly birthmark next to her mouth, he would turn up on a horse and she would be holding a flower between her teeth. The current meaning is "look superficially."

THIRD CHENGYU:
Hua long dian jing

Putting the last touch to the eye gives life to the dragon.

1. HUA. "Paint, draw." A suspended horizontal stroke is followed by a vertical line, a broken line in which a cross is drawn; we close the square with a horizontal stroke. Another vertical stroke is drawn on the left and then a horizontal stroke followed by a vertical stroke, as in the ending of *shan*, "mountain." *Hua* calls to mind a framed painting.

2. LONG. "Dragon." Horizontal stroke (always slightly ascending), a large left-falling stroke followed by another, much shorter one that cuts through—guess—a majestic dragon's tail and without interrupting its movement, the brush draws the final dot at the top right of the word.

3. DIAN. "Dot, drop." Short vertical stroke and then a short horizontal stroke grafted to its side, below which we draw a square ("mouth" in Chinese): vertical stroke on the left, a broken line, and closed with a horizontal stroke. Underline with four dots, one toward the left and three toward the right. This is how *dian* is written; remember the dot, which was your first step in calligraphy—it was a lifetime ago (or perhaps just a few pages back in this book).

4. JING. "Eyeball." This is composed of three simple characters. The first (the eye radical) is made up of a vertical stroke, a broken hook to make a box, inside which are two small horizontal strokes with a third to close it. The second is also easy: two horizontal strokes, a vertical stroke and a horizontal bar for it to stand on. And below this (have you left enough room?) a *yue*, the moon.

画龙点睛

Putting the last touch to the eye gives life to the dragon. It is said that an excellent painter decorated the wall of a temple with a dragon, without finishing its eyes. The monks insisted that he finish his work, so he put a drop of ink in the white of the eye to represent the pupil. Immediately, there was a flash of lightning and the temple wall was destroyed, while the dragon rose majestically into the sky. Today, throughout China, a grand opening ceremony can't be carried out without ceremonially putting a dot in the eye of a cardboard dragon, which then launches into movement, amusing the children.

"It's the last touch that makes the eye real"; this is the meaning of this *chengyu*, and a good one to meditate on while drawing each character, as it is often the last stroke that balances out the rest.

FOURTH CHENGYU:
Bei gong she ying

See a snake in your glass when it is only the shadow of a bow.

1. BEI. "Glass, cup." First element (tree radical, because in ancient times one drank out of wooden cups): a short horizontal stroke and then a long vertical stroke; from where they intersect, draw a left-falling stroke and a long dot. The second element is made of the same strokes, except that the bar is placed higher, the vertical stroke starts in the left-falling stroke, and the long dot doesn't touch the rest, in order to balance the structure properly.

2. GONG. "Bow." For this easily understood and ancient archery pictogram, there are four strokes: a broken line, a horizontal and a vertical stroke, and an enveloping hook to finish it off.

3. SHE. "Snake." The left element (worm radical): draw a rather flat mouth, draw a vertical stroke through it (not too long), then do a rising tapering line, with a dot at the end of it. The part on the right is made up of two subsets. For the first, start with a normal dot, then on the left draw a vertical stroke, a little longer than a dot, from which you will draw a flat hook (slightly ascending, as usual). This is a widely-used element: it is the roof of a house, under which a lot of things can happen.... Finish with a left-falling stroke and a dragon's tail, which are both familiar to you by now.

4. YING. "Shadow." Three associated characters: the first ("sun") is a line in a box (the bar that closes it is always done last). Below is a "landscape": a dot plus a line, then a "mouth," followed by *xiao*, "small." The whole of the right side of the character is occupied by three left-falling strokes; the first two are more or less equal and parallel, but the third deviates slightly toward the bottom and overshoots below its neighboring element.

杯弓蛇影

See a snake in your glass when it is only the shadow of a bow. Personally, I would be more afraid of the shadow of a bow than a snake, but the brave warriors of the era when this idiom was written all lived with weapons hung all over the walls and, after several servings of alcohol, it would have been easy to think the moon is made of green cheese, or to confuse bows with serpents. The man in this proverb—although a brave warrior—was in bed waiting to die, until his friend arrived to assure him that he hadn't been poisoned.

Chinese keys or radicals

Chinese is a thematic language, and Chinese characters can be grouped into families. For example, everything that has a relationship to water (all liquids or moisture, including sweat and the beach) is said with a character which, on the left side, contains a contraction of the "water" character. The same happens for fire, air, the heart (which marks feelings), and so on. This base character is called a key, or a radical, and it's what we use when searching in a Chinese dictionary. It is said that there are 214 radicals. Some of these radicals are very ancient and don't have a specific use. On the other hand, others are used all the time, such as the man, mountain, and air radicals. Knowing the radicals by heart is one of the easiest ways to start to learn this language, because all the characters they appear in will immediately seem less obscure.

Due to its extreme complexity, the knowledge and use of written Chinese was once reserved for the elite. However, when the reformers of the 1950s wanted to launch a vast wave of literacy throughout the country, many commonly used characters had to be simplified, because their many strokes made it difficult to memorize them. Westerners who learn this language always say that simplification was a good idea. It is, but—these same people say later on when they have become competent—it's a shame to lose the original layers of richness of the language. In any event, these simplified characters are very useful for improving and moving ahead in your calligraphy skills.

Of the 24 characters studied in this book, 8 have a complex shape. We have noted these as (A) in the chart here, which shows the three major styles.

The general rules of stroke order (see pages 70 and 71) will help you to integrate the characters, even those that haven't been explained in detail in this book, into your repertoire.

Chart of the characters and styles

#			#			#		
1 pg. 40	人	人 人	13 pg. 60	开	开 开	20 pg. 62	花	花 花
2 pg. 42	天	天 た	13 (A)	開	開 开	21 pg. 64	画	画 画
3	大	大 大	14 pg. 60	门	门 门	21 (A)	畫	畫 畫
4 pg. 44	小	小 小	14 (A)	門	門 門	22 pg. 64	龙	龙 龙
5 pg. 46	水	水 水	15 pg. 60	见	见 见	22 (A)	龍	龍 龍
6 pg. 54	月	月 月	15 (A)	見	見 見	23 pg. 64	点	点 点
7 pg. 55	有	有 有	16 pg. 60	山	山 山	23 (A)	點	點 點
8 pg. 56	朋	朋 朋	17 pg. 62	走	走 走	24 pg. 64	睛	睛 睛
9 pg. 57	文	文 文	18 pg. 62	马	马 马	25 pg. 66	杯	杯 杯
10	纹	纹 纹	18 (A)	馬	馬 馬	26 pg. 66	弓	弓 弓
11	雯	雯 雯	19 pg. 62	观	观 观	27 pg. 66	蛇	蛇 蛇
12	齐	齐 齐	19 (A)	觀	觀 觀	28 pg. 66	影	影 影

1. The horizontal line is drawn from left to right. If it is followed by a vertical line, a hook, etc., draw them at the same time without stopping; this will count as a single stroke. Example: 一 ㇀ 乛 ㇇

Similarly, elements combined horizontally to form a character are also drawn from left to right. Example:

In 好 start with 女 and then draw 子

2. The vertical line is drawn from top to bottom. If it is followed by a horizontal line, a hook, etc., draw them at the same time without stopping; this will count as a single stroke. Example: ㇑ ㇄ ㇄

Similarly, elements combined vertically to form a character are also drawn from top to bottom. Example:

In 安 start with 宀 and then draw 女

Apply the rules 1 and 2 for writing *kou*, "mouth." 口
㇑ 冂 口

3. When a horizontal line crosses a vertical line, the horizontal line is drawn first. Example: *shi*, the number 10: 十
一 十

Example: *zhong*, middle: 中 ㇑ 冂 口 中

The above only applies to straight vertical lines.

Mastering the order of drawing the strokes will help you to understand the logic of Chinese calligraphy, and is an essential part of its study (there is still the aesthetic side to learn, but that will be the subject of another book).

Happily, Chinese stroke order follows a few general rules that apply to thousands of characters, including the characters that aren't included in this book.

General rules about the order of the strokes

When left and right-falling lines cross, the left-falling line is drawn first.

丿 乂

4. If there are symmetric elements to be placed in relation to a vertical line, that line is drawn first, followed by the element on the left and then the element on the right.

Example: *xiao*, small: 小 亅 小 小

Example: *mu*, tree: 木 一 十 才 木

Example: *lai*, to come: 来 一 ⼁ 冖 ㄢ 耒 来

5. When a character has an exterior part enclosing elements, the exterior is drawn first. Example: *yong*, to use: 用

丿 几 月 月 用

But when the exterior part of a character is a closed box, the closing line is drawn last, after filling the interior. Example: *kun*, difficult: 困

丨 冂 冂 闬 闲 闲 困

Example: *hui*, to return:

回 丨 冂 冂 冋 回 回

安陽半紙

Some parting advice

The end of the journey is the only real departure

This book is nearing its end, so here is some final advice.

First of all, as you continue on in your practice of calligraphy, you will need more information about the rules that govern Chinese characters' structure. There are many books and websites that offer detailed information on the radicals and stroke orders.

Even though the ductus and the stroke orders are strict, unchanging rules, without which Chinese words wouldn't make sense, they aren't aesthetic rules in any way, and that allows each calligrapher to develop his or her own style.

In order to understand the potential for freedom this strict art offers, we have to pass through a phase called "imitating the old."

There are manuals printed in China (look for online sources) containing numerous perfectly-executed characters full of personality, gathered from the great classic works in *kaishu* by Ouyang, Liu, Yan, Zhao, and other masters. Using these manuals, beginners start by closely observing the details of a chosen character. Next, imitate it as best you can. By comparing your result to the original, you will discover a logic and an internal force in the original that you won't have noticed at first. You'll therefore try drawing it again, and you'll repeat that process over and over, learning more each time.

There are also dictionaries that collect the best forms each character has taken on over the centuries, and include the brush strokes of well-known calligraphers. One of these is called *Shufa Zidian*, "The Chinese Calligraphy Dictionary." These books aren't translated into English, but your careful eye will soon pick up the stroke orders.

This book and the above kinds of supplementary reference books and websites are obviously useful. However, they can't substitute for lessons from a real teacher, if you can find one. It's always enriching to learn from a master how he or she has interpreted, surpassed, and perhaps even trampled upon (!) the concepts that you've learned in this book.

"Noissap"
Diptych by Hachiro Kanno
76 x 120 cm

About Japanese Calligraphy

Japan, the "tomorrow" of Chinese brush art

When Chinese script spread throughout Japan in the first centuries CE, calligraphy, with all its rules, styles, and tools, was also integrated into Japanese culture. But Chinese characters (called *kanji*) weren't sufficient to transcribe the entire Japanese language, so the Japanese created supplementary symbols called *kana* that calligraphy immediately adopted for its own uses.

Their fine, dancing morphology produced a new, very much Japanese genre of writing, one with a gracious, flowing dynamism.

"Nondesire"
Toshiko Yasumoto-Martin
67 x 35 cm

"A voice"
Kenpo Hiramoto

The Japanese style of writing was definitively and deeply modified, to the point where the regular script (*kaisho*) taught today in schools in Japan is more showy than its Chinese counterpart. Through time, variants and refinements were thought up, as well as the subtle use of ink that created the essence of *sumi-e*.

Another colossal factor in the different direction Japanese calligraphy took was the development of Zen doctrine around 1400. This interpretation of Buddhism gave Japan a branch of calligraphy that favored spiritual intensity and vital energy—including "deformities"—over strict rules and harmony. We owe explosive and unconfined works to the hermit calligraphers of that period, works that were often done with one or two giant *kanji*, and which vibrate with a superb modernity—and a bit of what today's world calls punk style.

Therefore, it isn't surprising that in the 1950s the art of calligraphy intersected several new art developments: on one side we see Japanese calligraphies evolving toward abstraction, while on a parallel track, numerous American painters (like Motherwell, Pollock, Kline, and Twombly) absorbed the influence of this and borrowed from the spattering that Japanese monks invented five centuries ago.

Calligraphy has put down deep roots in Japan. More than four hundred calligraphy exhibits are held there every year.

"Storm"
Toshiko Yasumoto-Martin
55 x 35 cm

Chinese calligraphy's popularity continues on, through the passion of people not only in China's neighboring countries (like Japan and Korea) but also in the West, where we have only more recently learned how this purest, simplest way of expressing ourselves can develop into a sublime art.

Caoshu. Literally "grass" style. The freest and most creative cursive calligraphy. Cursive script of excellent quality is the goal of all beginning calligraphers.

Characters. Chinese "words" can be pictograms, ideograms, phonograms, etc.; only the word "character" can be accurately applied to all of them.

Chengyu. Set phrases used as traditional idiomatic expressions. Mostly composed of four characters, they can be used to make learning to write easier. See page 59.

Cursive. See *xingshu*.

Duan. Name of a region in South China that produces the best inkstones.

Gasenshi. The Japanese word for Chinese rice paper.

Hubi. Name given to the best Chinese brushes.

Ideograms. See *characters*.

Kaisho. Japanese for *kaishu*.

Kaishu. Normal script, well balanced and square; also called regular script.

Kana. Name given to specifically Japanese characters, in opposition to Chinese characters called kanji. Kana have a particular pattern that evokes stenography, and their slender, threadlike calligraphy is radically different.

Kanji. Japanese name for Chinese characters, which make up the major part of written Japanese words. In Chinese kanji is called hanzi.

Key. See *radical*.

Radical. Each Chinese character has a key, also called a "radical." It is sometimes present in condensed or varied form, and designates the character's semantic family. See the box on page 68.

GLOSSARY

Reisho. Japanese for *rishu*.

Rishu. "Clerical" style that existed before kaishu. It has a slightly stiff but aesthetically beautiful feel.

Shōdo. The Japanese name for calligraphy, literally "way of the script." The Chinese call it *shufa*.

Shufa. Literally "the how of writing," the Chinese name for calligraphy.

Sōsho. Japanese for *caoshu*.

Strokes. Without exception, all Chinese characters are made up of a number of basic strokes, listed as 1 to 19 in this book.

Sumi. Japanese name for ink (*mo* in Chinese). This term is modified to become *sumi-e*, ink brush painting, often practiced by calligraphers.

Tensho. Japanese for *zhuangshu*.

Xingshu. Semi-cursive (or running) script. A style in which the brush traces the movement to be made to the next stroke. A perfect knowledge of stroke order is needed for the use of xingshu.

Xuanzhi. Paper used for calligraphy and painting; there are dozens of varieties. *Zhi* means "paper" (*shi* in Japanese). *Xuan* is the name of a region in ancient China where the best rice paper was made.

Zhuangshu. Seal script. A stiff but neat script dating back to before brushes, when calligraphy was engraved. Today writing zhuangshu with a brush is a scholarly art.

Lucien X. Polastron is a historian specializing in Chinese and Japanese subjects, and arts tied to writing and literature. The author of more than a dozen books, he is a producer at Radio France's station "France Culture." He lives in Paris.

Jiaojia Ouyang was born in Shanghai. His award-winning calligraphy and paintings have been widely exhibited in Beijing, Shanghai, and France. In 2000, Ouyang created his own particular style by joining Eastern and Western influences. He lives in Toulouse, France, where he teaches Chinese calligraphy.